WISDOM WARRIOR

NATIVE AMERICAN ANIMAL LEGENDS

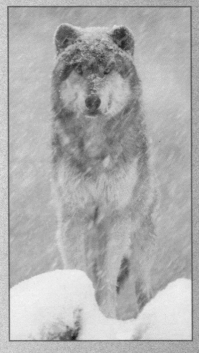

DENNIS L. OLSON

NORTHWORD PRESS
Minnetonka, Minnesota

INTRODUCTION

IT IS TRUE THAT MANY OF THE OLD WAYS
HAVE BEEN LOST, BUT JUST AS THE RAINS
RESTORE THE EARTH AFTER A DROUGHT,
SO THE POWER OF THE GREAT MYSTERY WILL
RESTORE THE WAY AND GIVE IT NEW LIFE.

WE ASK THAT THIS HAPPEN NOT JUST FOR THE RED PEOPLE,
BUT FOR ALL THE PEOPLE, THAT THEY ALL MIGHT LIVE.

—LAKOTA PRAYER

This book is about an opportunity. It is about new ways to see, a perspective that has been hiding in plain sight since the beginnings of our interactions with the First Nations on this continent. Those who lived comfortably and sustainably on this land for twenty thousand years did so because of their world-view. Perhaps, if we are willing to put away fear and truly listen, they can teach us how to survive here for twenty thousand more.

"Story," "myth," "fable," "tale"—all of these words have come to represent something we don't have to take very seriously. Yet, stories are perhaps the most uniquely "human" thing about us. In Western thought, stories are entertainment or a way to kill time. Native American stories have been thought of as "cute" tales of animals for the amusement of children. The Western frame of reference is one of separation—the processes of Nature are removed from the human world, fact is absolute, perception can be purified of bias, observers are different from participants.

In the Native world-view, there are *only* participants, for the act of observing is itself a form of participation. Thoughts, feelings, actions, and stories are interwoven throughout Nature, and everything, even the darkest secret feelings we tell no one else, has a set of consequences connected to it. It is no wonder that traditional Native People

act with such a sense of responsibility toward the land. They see no difference between the land and themselves. This view, of course, makes the land sacred, and ourselves simple and temporary expressions of the land.

Life is also inclusive in the Native world-view—everything is alive. "Beings" include the soil and the stars. And most important, no individual is alive all by itself, in a vacuum. Science, perhaps unintentionally, actually supports this perspective, because we completely replace the atoms in our bodies every seven years or so, making us "recycling processes" rather than separate individuals. Our molecules are recycled mastodon, trilobite, and star-dust. John Muir once said that everything is hitched to everything else in the universe, but he had it only half right. We are not only hitched to everything else, we are made of everything else.

From that perspective, traditional Native Americans watch animals carefully. Their lives depend on the knowledge they gain from their observations. Most animals are endowed with certain traits of character, and Natives try to imitate the behaviors they admire, to form themselves in the image of those ideals. There is no assumption, as in Western society, that animals are somehow inferior to two-leggeds. There are human people, bear people, tree people, rock people—all equally gifted with their own world-view.

The level of respect given to the rest of Nature by Native peoples on every continent shows this same wisdom. Without any fossil record to guide them, there was, and is, the assumption that all other "people" are our elders, and they should have the same respect as human elders.

Considering the struggles we are now having with our own environment, perhaps it is time to listen to some of the old teachers—the ones who have been here for eons. Native People simply listened to the rest of the Earth with an open heart, giving voice to bear, eagle, bison, and stone, and continue to carry the water through the metaphorical desert, to us. In these chapters, perhaps we can take a sip or two.

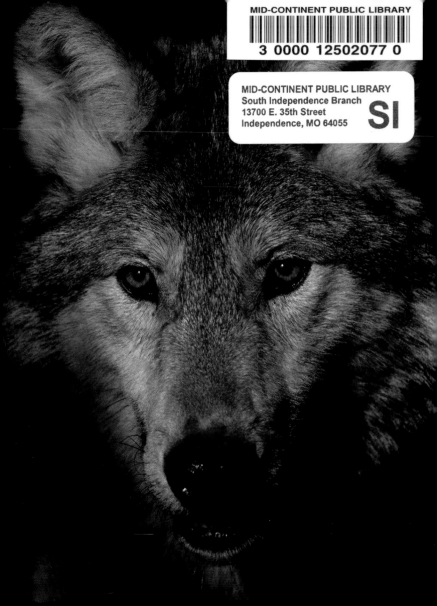

Wolf
WISDOM WARRIOR

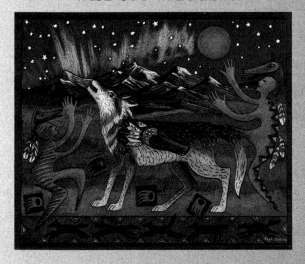

A WOLF I CONSIDERED MYSELF
BUT I HAVE EATEN NOTHING
AND FROM STANDING I AM TIRED OUT.
A WOLF I CONSIDERED MYSELF
BUT THE OWLS ARE HOOTING
AND THE NIGHT I FEAR.

—TETON LAKOTA SONG

NATIVE AMERICANS often used the wolf as an ideal, sometimes to point out their own limitations, such as fear of the dark. The Blackfeet/Blood/Piegans of the Northern Rockies spoke of a harmonious life as traveling the "wolf trail." Many traditional people thought that the eyes of the wolf and the eyes of the human were the same eyes.

Wolves taught us about cooperation and the value of our extended families. They taught us about protectiveness and about fidelity to our pack. They taught us how the social system in a pack functions smoothly, and with the best interests of everyone in mind. We watched them, and learned how to "howl at the moon" in celebration. They showed us how to move through the world carefully and quietly. It has been said that wolves are the creatures most like us, but perhaps we have our seniority system mixed up. Perhaps we are the creatures most patterned after wolves.

Native Americans rarely looked at the wolf as a competitor or enemy. If game was scarce, the wolves would be gone. The presence of wolves was a good sign. The good hunter watched

wolves for signs of bison or elk, and he never killed without offering some meat to this assistant and scout. Eventually, this relationship blossomed into one in which we call the wolf "man's best friend." Long ago, wolves and humans realized their brotherhood, and made a truce. The wolves still observe it.

A Blackfeet woman named Sits By The Door was captured in a Crow raid and carried hundreds of miles to Crow country as a prisoner. She escaped with the help of a Crow woman, but nearly starved when she was still far from her people. She watched helplessly as a wolf came close by and lay down, probably waiting for her to die. She told her story to the wolf. Next morning there was a fresh-killed buffalo calf next to her on the ground. She ate, regained some of her strength, and resumed her journey. She still could barely walk, so the wolf walked next to her and supported part of

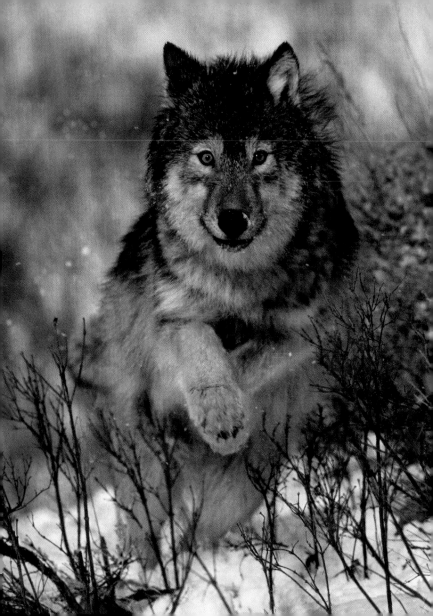

her weight. They traveled together for days, and the wolf continued to bring kills to her. By the time she reached her people, she was as strong as before she left. She camped just outside the village because the wolf was still wild, but the camp dogs eventually ran it away. The woman became sick and eventually died. It was said that the wolf would look for Sits By The Door from a nearby butte for many years after.

The relationship between wolves and humans is summarized well by the story of Sits By The Door. The camp dogs were not comfortable with their wolf origins, nor are people today comfortable with theirs. We prefer to call ourselves "civilized" but our wild tendencies still wait for us, just outside of our camp....

Humans fear what they don't understand. Red Riding Hood, Three Little Pigs, Peter and the Wolf, crying wolf, wolfing food, wolf at the door, thrown to the wolves, werewolves—these are the wolf legacy from Europe and white America. A Pawnee story tells that it was once that way with the Native American nations too.

Creator, with the assistance of Lightning and Thunder, sang, shook rattles, and struck the

ground and water with their clubs. In this way they created everything we see today—except one. They forgot about the Wolf. A great red star in the southeastern sky was curious about creation and changed itself to a form that could run across the land and see things far and wide. This form was Wolf.

Thunder picked hundreds of stars from the sky, put them in a whirlwind sack and went down to examine the creation for himself. Thunder explored many places, occasionally putting the sack down and watching with amusement as the stars would spill out and try to run away, on two legs. He sucked them back into the whirlwind sack and explored new places.

Wolf had picked up Thunder's trail and followed it until he found Thunder asleep. Thinking there might be food in the bag, Wolf quietly nipped at the strings of the whirlwind sack, and out poured two-leggeds, who ran off and set up camps all over creation. An old woman from the bag adopted Wolf and fed him buffalo meat. One day hunters came back from a hunt empty-handed and angry. They wanted to blame someone. When they turned around to look

behind them, they saw Thunder roaring their way, himself angry at losing his two-legged toys. They were afraid, and in their fear and anger, the hunters shot Wolf and killed him.

Thunder was angry that the two-leggeds had run away, but he was even angrier that they had killed some-thing just because they didn't understand it. Thunder roared at them for being afraid of mystery, and told them that they were no longer welcome in the whirlwind sack, where they would have lived forever. He told them that mystery would always be replaced with another mystery, and the new one was the mystery of death. Since that time, the Earth has lived with death nearby.

Today, the Pawnee call themselves the Skidi Pawnee, the Wolf People. Their scouts are legendary, operating just like a wolf pack in hunting and warfare. The metaphor of this story is remarkably similar to our world.

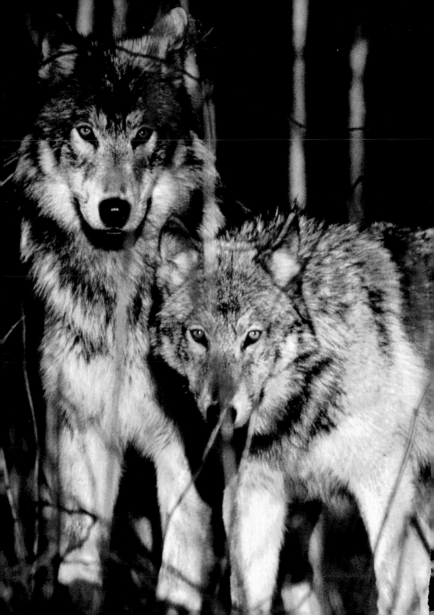

We kill what we don't understand, and it will, with certainty, bring more death into our world.

To Native People, ecology was not something taught from a book. It was "the way things are," to be lived on a daily basis. It did not take much observation of "the way things are" to realize that the herd animals and the wolf are dependent on each other, and that the elimination of deer, elk, and caribou would be a very stupid thing for the wolf to do, even though he easily could. The agreement between the wolves and prey is that the wolf will pursue only hard enough to catch some animals, but not all. It took our culture many generations to discover this basic principle of predator-prey relationships. All we had to do was ask....

Wolf reminds us that we have a choice before us. We can carefully use some of the Earth for our own benefit, or we can choose to believe that we have a right to it all. Always, out there in the night, Wolf is watching patiently to see if any wisdom is rubbing off.

Someday perhaps we can look at Wolf the way Wolf sees us. According to Native People, we have the right eyes for the job.

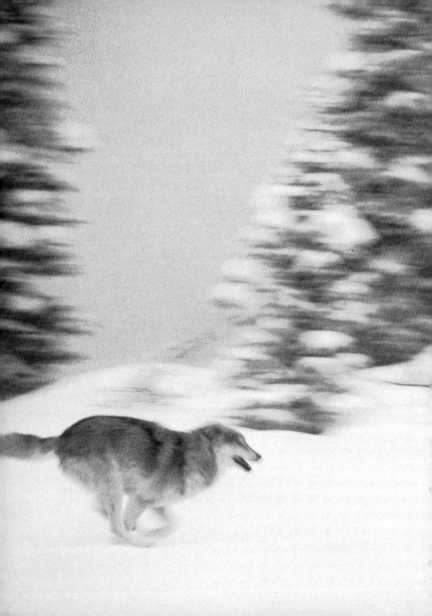

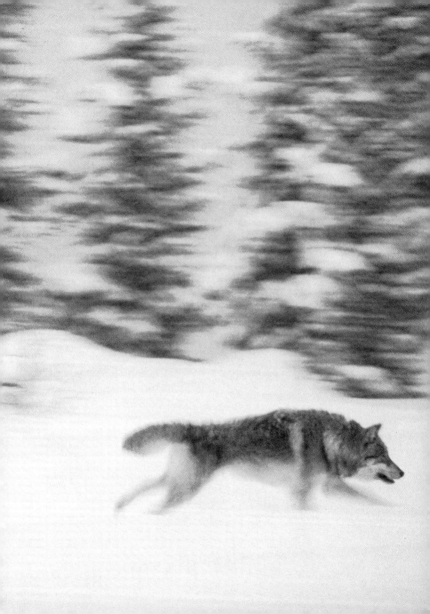

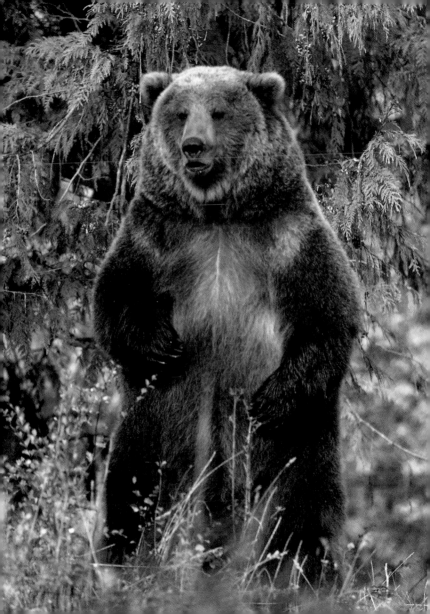

Bear
THE WILD WITHIN

I AM LIKE A BEAR.
I HOLD UP MY HANDS
WAITING FOR THE
SUN TO RISE.

—NORTHERN UTE SONG

TO NATIVE PEOPLE, bears are us, or at least part of us. That wild, untamable side of us is the part that becomes the bear, when we let it. Bears put on the intellectual skins of humans and walk among us. We put on the emotional skins of bears and disappear into the dark mystery of the forest. So awesome is the bear, so unmentionable the wild side of the human, that many Native People do not, from respect, ever address the bear directly by name. The "dark thing" (Haida), the "unmentionable big animal" (Blackfeet), the "one going around the woods" (Tlingit), the "four-legged human" (Cree)—all are terms of respect and honor, usually preceded by an expression of relationship like "Brother" or "Grandfather."

Native American stories of Bear are told in two basic forms, and sometimes they are a combination of the two. In one form, a woman becomes mated to a bear, and in the other form, a bear is killed (temporarily) with great ceremony. Often the "transformation" represented by the bear den is death. The bear and the human are interchangeable, and death is only a metamorphosis to another side of ourselves. Sleeping

through an entire winter, in a den, demands introspection and self-knowledge—the primary sources of power for a human.

A Micmac and Iroquois story begins with a bear hunt in progress. Three brothers have wounded a bear in its back. A bear will always seek the most remote and secret place to hide when it is in danger, and this one heads up the tallest mountain. The brothers press on right behind the bear, so close that the bear keeps running right into the sky. Still, the brothers do not give up, and follow the bear. The chase is still unfolding today. The Great Bear, Ursa Major, still runs across the sky as the four "cup" stars of the Big Dipper. Hot on the trail are the hunters, the handle of the dipper. The second hunter carries a cooking pot, a faint star close by, just in case the brothers finally catch and kill the bear.

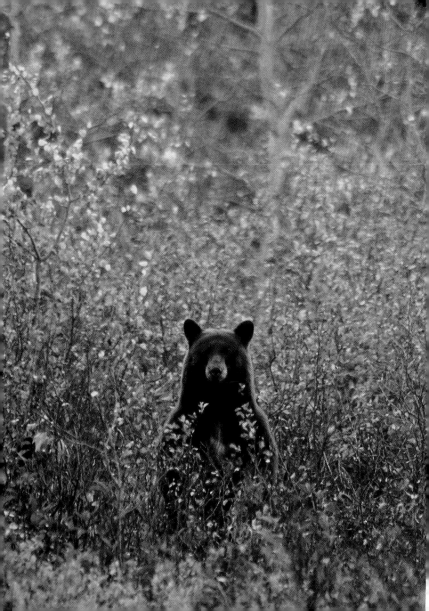

And there is evidence that this story is still developing: Every autumn, when the sun has set, the Great Bear runs upside down across the sky. The wound on its back spills blood, turning the leaves red on the land below.

One of the constant human transformations is a developmental passage from one world into another. Many cultures recognize that these passages exist—such as childhood to adulthood—and then design rites to ease the transition. A son "dies" to his mother (representing the childhood need for nurturing) and is reborn to the adult world. Some Native nations perform bear rituals in their initiation rites. The young men dance a bear hunt, "kill" the bear (to prove their worthiness), sleep in its den, and are reborn as a bear—a fierce and capable warrior. When they hunt the bear, they are hunting for bear qualities within themselves.

In the Cree tradition, a boy was once found and raised by a bear. The boy's human father never gave up hope of finding his lost son. He finally suspected that a bear may have captured the boy and began to hunt the bear. This was a hunt based on the power of individual spirits—

hunter and bear each sang their own songs to see which was the most powerful. The wild side and the human side struggled for the spirit of the boy. The human father won, and killed the bear, but he realized that there was value to the "bear" side of the boy and wrapped one of the legs of the bear as a "gift" for the boy. The son kept the gift, and became the best bear hunter anyone could remember. A woman of the tribe became jealous of the young man's accomplishments, and wanted her own son to be the best hunter. She unwrapped the bear leg, but the gift of hunting skill was not transferable to anyone else—the bear-boy had lived with a bear, after all. Immediately, the bear-boy turned into a bear and disappeared into the forest. Without its hunter, the village never knew the same kind of hunting success again.

Most of the woodland people, including the Ojibwe, Cree, Sauk, Fox, and Micmac, have a story about the importance of keeping *both* sides of ourselves. A pregnant woman, carrying twins, was killed by a horrible monster. One of the twins, Lodge-Boy, stumbled into a village and was raised by humans. The other twin was

thrown into the woods by the monster and was found and raised by bears. Throw-Away-Boy was caught one day by the villagers, and reunited with his brother. Together, they had enough power to hunt and kill the monster.

Both Lodge-Boy, the reasoning human, and Throw-Away-Boy, the emotional and creative one, were necessary to the balance. It is from this tale that we learn that life's monsters, whether psychological or spiritual, can only be defeated with a balanced, whole person.

The Blackfeet people tell of a woman who went berry-picking. She went into the mountains wearing a bear skin. There she was enchanted by a bear-man, and followed him to his cave. Even though he was massive and commanding he reassured her by gently removing a bone comb from her hair and speaking softly. They made love,

delicately and wildly, and she decided to stay with this bear-man. The villagers searched for her, and called out to the bear to fight. Bear-Skin-Woman begged him to stay, but he told her he must go, to honor an old war agreement between the humans and the bears. He was killed.

The people honored the bear by ritually and carefully cutting the meat in the woods, and eating him entirely—their part of the old bargain. When the woman came out of the cave to search for some sign of her mate, she found a tiny piece of fat the people had overlooked, which she washed carefully and put under her dress. In her grief, she changed into a bear and killed some of the villagers so quickly they did not have time to react. Then she disappeared into the forest.

When her grieving time was over, she changed back into a kind woman who took

care of her relatives. One day she was gathering cactus to feed everyone and the sharp needles poked her until she became pained and angry. Again, in her pain, she changed into a bear and marauded the village once more. Her nephews shot arrows at her and missed, all except the youngest. His arrow pushed her out of the camp. Still she did not give up, and attacked again. The youngest nephew used a magic feather to build obstacles in front of the bear, but finally had to retreat by climbing a tree with his brothers. Realizing that the bear was too powerful, he shot his brothers with the arrows, pushing them into the sky, where they became stars. He then tricked the bear into climbing the tree and shot the bear into the sky, too. To this day the Great Bear chases the nephews (in contrast to the Micmac story) across the sky.

All of this intermixing of bears and humans is acknowledgment that there are no "objective observers" in this world, only participants. We eat the bear, and we are the bear. The bear eats us, and the bear is us. We watch the bear and the bear teaches us. Its spirit is part of us.

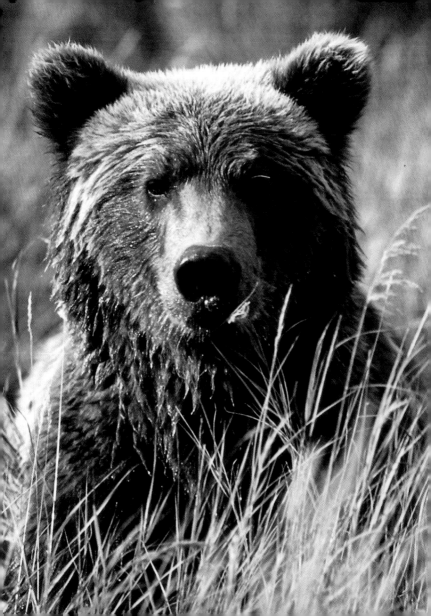

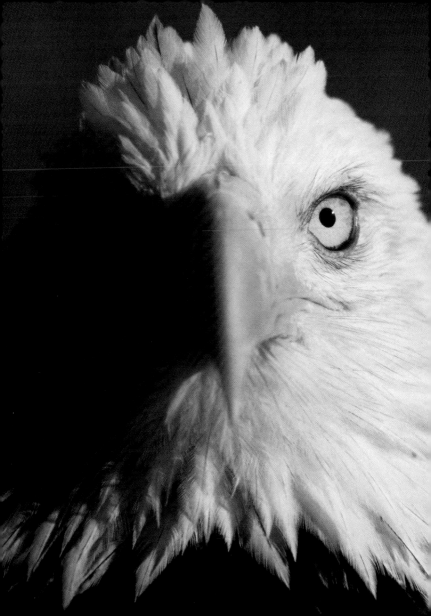

Eagle
THE SACRED SEER

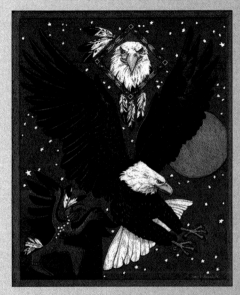

I AM AN EAGLE.
THE SMALL WORLD LAUGHS AT MY
DEEDS, BUT THE GREAT SKY KEEPS TO
ITSELF MY THOUGHTS OF IMMORTALITY.

—TAOS PUEBLO SONG

(interpreted by Nancy Wood)

EAGLES ARE THE EMISSARIES from the sky. Eagle feathers are sacred pieces of spirit— never worn as casual adornment, but as reflections of a person's vision and accomplishments. They are expressions of bravery, good judgment, humility, and special perspective. Feathers were, and are, constant prayers floating on the wind, back and forth from our world to another that is invisible to us. Eagle feathers are the dreams of the seer, the freedom of choices, the link between the material and the ethereal. The flight of the Eagle is the release of our earthbound nature, and the joyous passage to the next world. When we transcend any of our human limitations, we fly with the Eagle.

The Iroquois thought of Eagle as a benevolent Cloud Spirit, who carries dew between his shoulders and sprinkles it on the people when they have need. All across the Great Plains, Native Americans think of Eagle as the visionary, the one who sees the world far from itself with clarity and understanding. The eastern morning sky is golden, the color of the Sun's fire on Eagle's back. Morning is the time of birth of a day, and illumination of the world. On the Medicine

Wheel, Eagle is the seer, the one who calmly, patiently, and clearly can assess a situation and act well in the face of distraction. Eagle's eyes miss nothing.

Once long ago, according to Ojibwe tradition, medicine societies began to use their power for selfish reasons. They made people fear them and distorted and took the lives of others for personal gain. The Creator was angry at the twisted sickness on Earth, and decided to destroy everything after four days had passed. Just before dawn on the fourth day, Eagle flew from the space between dark and light, up toward Creator. He screamed his song four times to get Creator's attention. Creator agreed to delay the dawn until Eagle had held council with him.

Eagle admitted to Creator that the world was full of evil, but he also said he had seen a few humans who had remained true to the

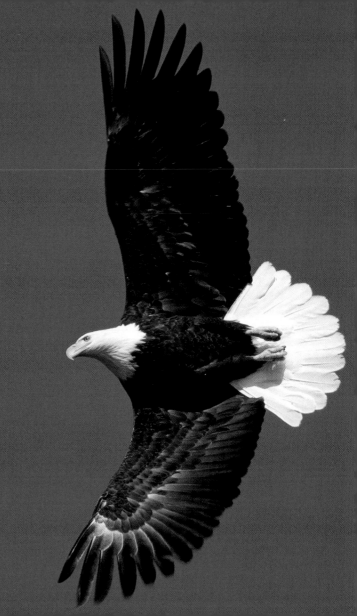

teachings of kindness and harmony. Here and there the sacred tobacco smoke still rose from a lodge. Eagle saw humility in the ways of a few people, and pleaded with the Creator to call off the coming destruction in their name. He offered a deal. If Eagle could fly over the Earth and report every day to Creator that there were still some who followed the good road, Creator would not destroy the world. If there was someone doing a good deed, sounding the Drum, observing the Sacred Circle through the Pipe, or thinking of the unborn, Eagle would report to Creator that there was still hope in the world. Creator agreed, saying that the deeds of the born should not overrule the promise of the unborn.

Eagle still flies to the Sun every day and we may wonder if things look better now than they did then....

The spirit world is a place where Eagle also flies every day, and his connection to departed spirits was assumed. In a Yakima story, Coyote and Eagle were both mourning the death of relatives. Coyote decided to comfort Eagle by pointing out that even the plants that die in the

fall are making room for new flowers and leaves. He said that the dead also feed the new. But Eagle was not consolable. He wanted his dead relatives back right now. He talked Coyote into going with him back to the land of the dead. They traveled a long time, and finally came to a huge lake, with houses on the other side. Coyote called for a boat, but no one answered. They waited until dark, and Coyote began to sing a special song. Four people made of fog came out of a house and began to paddle their canoe over to pick up Coyote and Eagle. They kept time with Coyote's song as they paddled.

They arrived at the village on the other side and the Fog People warned Coyote and Eagle not to look to the side in this sacred place, only straight ahead. Coyote asked if they could at least go into a lodge and have something to eat. The Fog People took them inside and fed them. The next night, Coyote stood next to the moon as the Fog People woke up and began to dance. Coyote swallowed the moon, and in the confusion, Eagle gathered up all the Fog People and put them

into a basket Coyote carried. They closed the lid tightly.

As Coyote carried the basket closer to the land of the living, the Fog People began to come to life as Spirit People and talk inside the basket. The basket became much heavier. Coyote had to stop and rest more often as the bas- ket became heavier and heavier. He finally said to Eagle, "We should let them out to walk by them- selves. They will never find their way back now."

It took some convincing, but Eagle finally agreed. They opened the lid and the Spirit People immediately flew like Wind back to their village across the lake, and again became Fog People. Eagle was disappointed, and asked Coyote to go back and try again. Coyote refused, saying that the weight of the dead would be too much for the living, and that people should stay in the other world when they die.

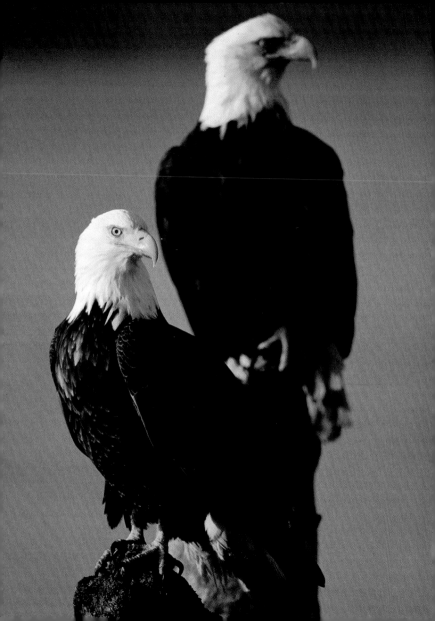

Eagle saw the logic in Coyote's argument, but he still flies to the Spirit World each day, to bring messages back and forth. If we miss someone, we can trust Eagle to deliver our comforting message. And sometimes the Fog People just want us to know that it's OK over there....

With the slicing vision of Eagle, we can avoid being blinded by fear of the unknown. Eagle moves like Wind, through all worlds and all things, circling the Sun, reporting on our condition. With the help of all the Peoples, feathered, finned, legged, and green, some of us will remember to have pipe smoke coming from our lodges. For now, it's still OK over here, too.

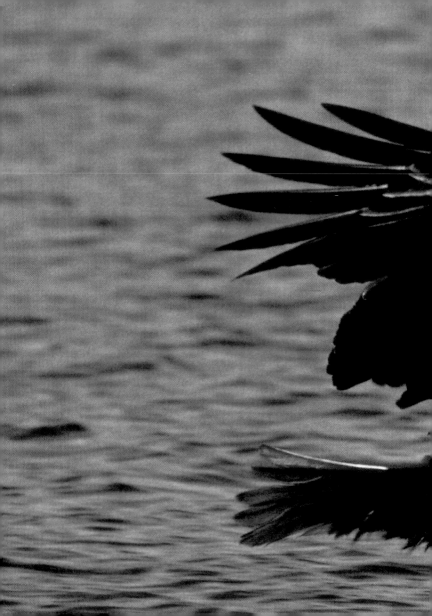

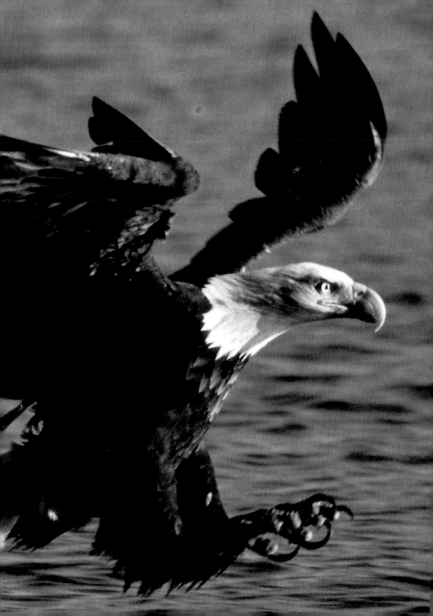

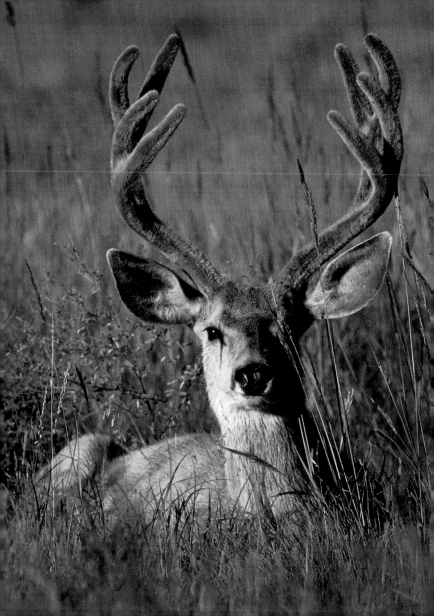

Deer

MOVING GRACE AND SAYING GRACE

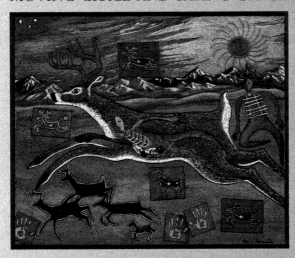

I HAD NEED.
I HAVE DISPOSSESSED YOU OF BEAUTY, GRACE, AND LIFE.
I HAVE TAKEN YOUR SPIRIT FROM ITS WORLDLY FRAME.
NO MORE WILL YOU RUN IN FREEDOM
BECAUSE OF MY NEED.
I HAD NEED.
YOU HAVE IN LIFE SERVED YOUR KIND IN GOODNESS.
BY YOUR LIFE, I WILL SERVE MY BROTHERS AND SISTERS.
WITHOUT YOU I HUNGER AND GROW WEAK.
WITHOUT YOU I AM HELPLESS, NOTHING.
I HAD NEED.
GIVE ME YOUR FLESH FOR STRENGTH.
GIVE ME YOUR COVERING FOR PROTECTION.
GIVE ME YOUR BONES FOR MY LABORS.
AND I SHALL NOT WANT.

— OJIBWE PRAYER TO A SLAIN DEER

41

IN WESTERN SOCIETY we have a relatively new movement, in reaction to the land-hungry way of thinking, which assumes that life is sacred. Traditional peoples would agree, in part. But, thinking only as far back as breakfast, they would also remind us that death is sacred too, as is soil formation from dead bodies, killing, eating, defecating, and all of the other processes of the universe. No matter what our philosophical point of departure, Western society still stubbornly refuses to look through a wide-angle lens.

The assumption of Native Peoples, a logical one from a perspective of equality, was that all beings deserved life. This led to a paradox, especially concerning the deer, because in order for humans to live, some deer had to die.

If there is a recurring theme in Native American stories about deer, it is one of reconciliation of this paradox. If animals were ever taken for granted, they would be justifiably insulted, and refuse to give themselves to humans thereafter. The subtle message is that deer make choices too. Instead of the

human-centered view that "I can't hunt very well," there is a humble acknowledgment that the world has its own plan—independent of our wishes. An unsuccessful Native hunter would more likely say, "Deer don't want to die for me today."

A story from the Ojibwe is quite blunt about the human responsibility to be humble. The deer had vanished from the land of the Anishnabeg, the First People, and the humans roamed over the world in search of them. Owl, who often foretells things to come, found all the deer in a huge corral far to the north. They grazed and browsed as if nothing at all were wrong. The curious owl flew down to question the deer, but a flock of crows attacked the owl and drove it away.

When the owl reported the location of the deer, the humans formed a large war party to rescue them. Owl guided them back to the gates of the enclosure, but they were surprised by an attack of the fierce crows. The battle lasted for days, but no side gained an advantage. The deer made no attempt to escape—they just watched.

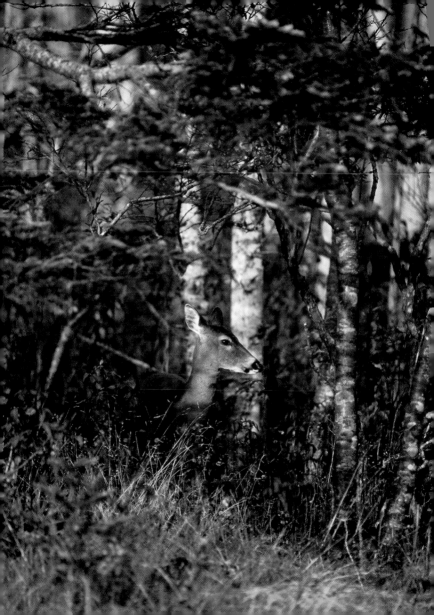

Finally the chief of the humans asked for a truce, realizing that defeating the crows would cost as much in human suffering as in crow suffering. The crows laughed that humans needed to learn this lesson in such a difficult way.

Then the chief of the Anishnabeg asked the deer why they were so unconcerned about the rescue attempt, especially since the war party had suffered so much. The deer chief answered that they were in this place by choice—the crows had treated them much better than the humans ever had. Humans had wasted their flesh, spoiled their lands, and desecrated their bones. They had dishonored the deer and therefore themselves. "Without you we can live very well, but without us you will die."

The Anishnabeg promised to stop offending the lives, deaths, and spirits of the deer, and the deer followed the humans back to their lands. Today, they honor this as the oldest and most sacred treaty. It is unthinkable to forget where life originates—from the deer's gift of itself.

The Wintu people of Northern California believed that the successful taking of a deer had a prerequisite level of skill, preparation, and respect, but the crucial element was the choice made by the deer. If any part of the human responsibility—not wasting, humility, gratitude, courtesy—is forgotten, the deer will "forget" to show up next time.

The Cherokee believed that this level of respect had direct positive effects on individuals, and direct negative effects if the rites were not done in sincerity. A long time ago, humans and deer lived in peace. Humans hunted and killed deer only when they needed food and clothing. Then something happened that changed it all—they invented bows and arrows. Humans could now kill at great distance, effortlessly. They began to kill unnecessarily, and the animals were afraid they would be eradicated. They had a meeting.

The bears made bows even stronger than the human bows, but their claws were too long to shoot them. And when they removed their claws they could not climb trees. So the bears decided against such a compromise.

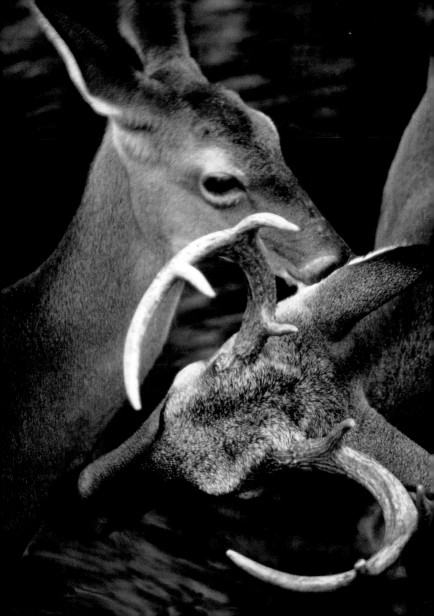

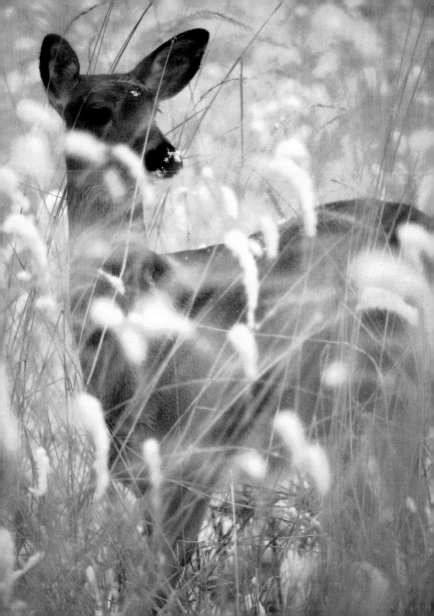

The other animals met in their groups and attempted to find a way to fight the humans, but they had as little success as the bears. The last group to meet were the deer, whose leader was Awi Udsi, Little Deer. They realized there was no way to stop the humans from killing, but there might be a way to change the *way* they killed. Awi Udsi went to the humans in their sleep and told them that they must prepare for the hunt with rituals. They must ask permission to take a deer. They must ask for pardon from the deer's spirit after the kill. If they did not do all of these things, the meat from the deer would make them sick and crippled.

A few hunters didn't believe that Awi Udsi was anything more than a dream and soon became crippled and sick. Those who understood the dream lesson, that everything is dependent on everything else, never again took the presence of deer for granted, learned to say "grace," and never wanted for deer to eat.

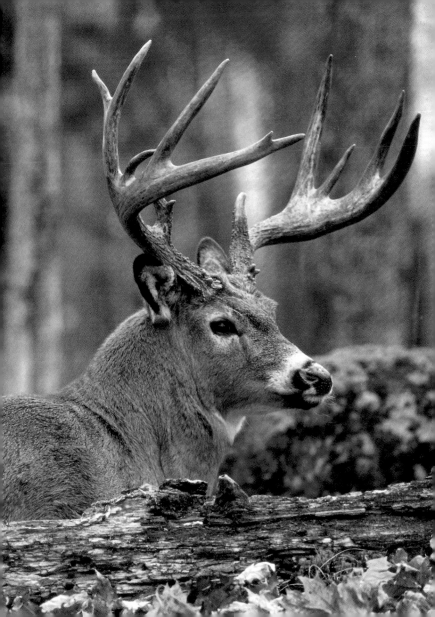

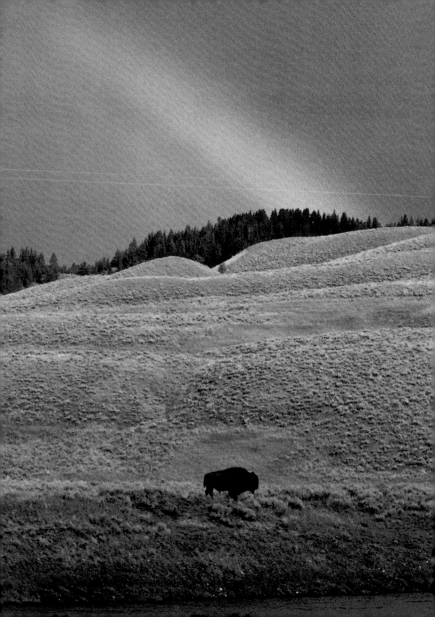

Buffalo
THE MESSENGER

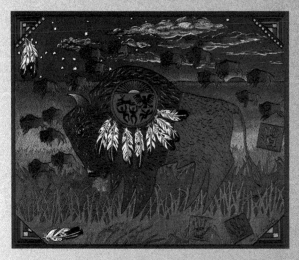

STRIKE YOU OUR LAND
WITH CURVED HORNS.
BENDING OUR BODIES,
BREATHE FIRE UPON US.
NOW WITH FEET
TRAMPLING THE EARTH,
LET YOUR HOOVES
THUNDER OVER US.

—BUFFALO DANCE—OJIBWE

NO ANIMAL is more associated with Native America than the buffalo. The plains, mountain valleys, and even open pockets of land in the eastern woods once held vast herds of these huge, shaggy creatures. As with the salmon of the Northwest, buffalo were synonymous with life to the plains people. Offending the Buffalo Spirit, taking any chance that the herds might not come, was suicidal.

Nothing on the prairie was more powerful than the buffalo, physically or spiritually. On the Medicine Wheel, the buffalo represented the north direction, the place of wisdom, renewal, and personal power based on knowledge. The color of the north is white, the color of winter snows. When the color and the buffalo mixed together, the result (a rare white buffalo) was a powerful and compelling message to the people. The Lakota trace the spiritual origins of their culture to the visit of one such omen.

Long ago, before they had horses, two Lakota scouts were sent to look for the herds. Their people were starving. They searched for many days, but saw nothing to hunt. One day they looked west from the top of a hill and saw

a woman walking toward them. She was dressed in a buffalo robe, but it was pure white. One scout recognized her as a very good and powerful being and he felt all the positive emotions inside of him well up. The other scout was afraid, angry, jealous, and lusted after this woman because he had not seen a woman for a long time. He reached for her and was struck by a lightning bolt, leaving a pile of bones.

White Buffalo Calf Woman told the other scout she wished to bring a medicine bundle to his people. It was a gift from the Buffalo People. She told him to build a medicine lodge in his village, and that she would be there after four days. He did as he was told.

When she came to the village, the people welcomed her and gave her the seat of honor in the lodge circle. She gave them some sage to smudge the lodge and clear their minds. Inside the bundle she carried a pipe bowl made of red

stone and a stem made of wood. She explained that the red bowl represented the blood of the Animal People, including them, humans. And the stem represented all things green and growing. The smoke from the pipe represented the Wind Spirit, which moves through all things and binds them together. She showed them how to fill the pipe, offering kinnikinnik to the four directions, the Earth Mother, and the Sky Father. This should be done "sunwise," starting with the east (birth), then to the south (growth), the west (elder years), and to the north (death and renewal). They should hold and pass the pipe in the same direction around the circle, swinging the stem around the bowl in the same direction. In this way the people would always remember the circles of life, death, rain, migration, seasons, days, moons, and moods.

"The Pipe should always be smoked in silence," she said, "so you can remember what I have said today." She stood up, went outside, and rolled on the ground. She stood up again as a yellow buffalo. She rolled three more times, standing as a green buffalo, a black buffalo, and finally as a white buffalo. Then she walked away

over the horizon. As long as the people remembered, the buffalo remained around their camps and gave themselves away when the people needed them.

In recent months, a white buffalo calf was born on a buffalo farm in the Midwest. It has been visited by thousands of people, who are waiting for a new message from an old, old Messenger. The great herds have been gone for a hundred years now. The new people on this continent did not hear the message. Perhaps the Buffalo will give us another chance.

The Kiowa tell of the end of the Buffalo, and for all practical purposes, the end of a Nation of people too. When the settlers came, building railroads and raising cattle, the Buffalo, who had a contract with the Native People, tore up the railroad tracks and chased the cattle off the range. They loved the Red People and the Red People loved them. They were brothers who exchanged many gifts. The settlers sent the horse soldiers to kill Kiowa, and the hunters to kill Buffalo. Each hunter killed a hundred buffalo per day, the hides were piled high on the railroad cars, and the carcasses left to rot on the prairie.

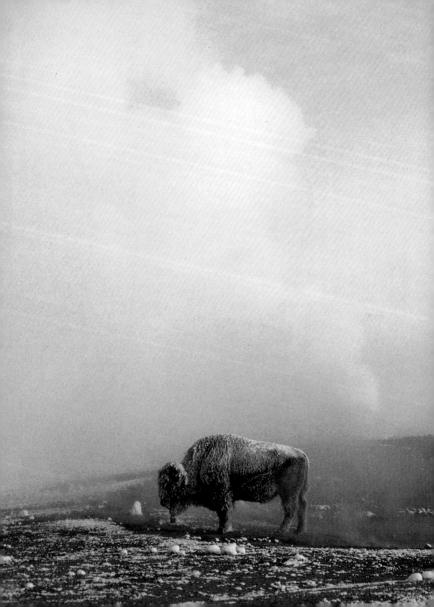

The people had never seen such disrespect of the powerful Messenger. The waste was beyond the comprehension of a people who were careful to use every last sinew and bone chip when they killed. They could not understand such carnage and destruction. These could not be real humans doing this....

The Buffalo could no longer protect the Kiowa, and apologized for failing to do so. The Buffalo held a council and decided they must go to a place where the settlers could not go. They offered to take the Kiowa with them, but the Kiowa decided to stay on their land, the place they had lived for thousands of years. The next morning, in the mist before dawn, the Buffalo People walked to the foot of a large mountain. The mountain opened up and swallowed the Buffalo forever.

It is clear that the Buffalo will not come back from inside the mountain until we begin to understand ourselves. A new White Buffalo Calf is now among us. Perhaps this is a beginning.

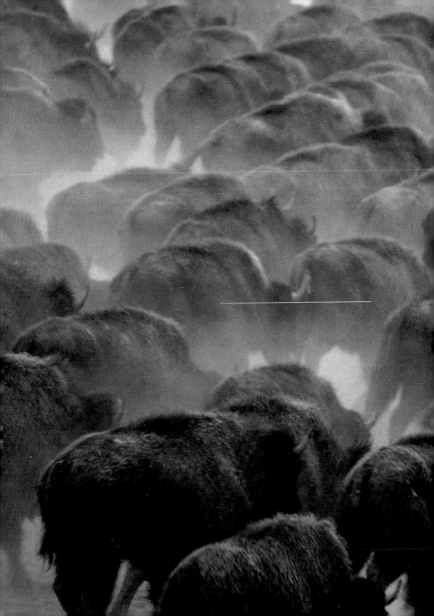

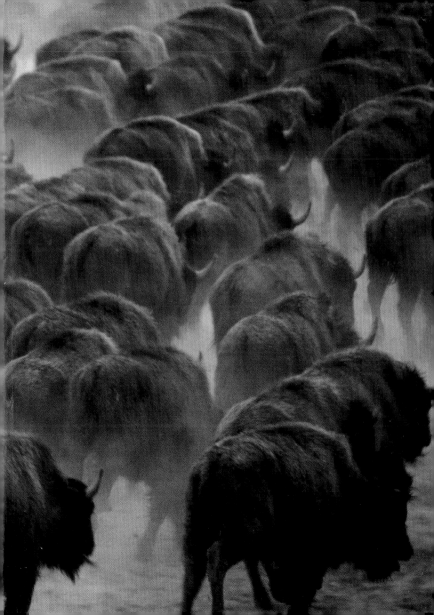

Book design by Russell S. Kuepper
Illustrations by Kay Povelite

The text, photographs, and illustrations have been adapted for this edition from *Shared Spirits: Wildlife and Native Americans* by Dennis L. Olson.

CREATIVE PUBLISHING international

NorthWord Press
5900 Green Oak Drive
Minnetonka, MN 55343
1-800-328-3895

Library of Congress Cataloging-in-Publication Data

Olson, Dennis L.
 Wisdom warrior : Native American animal legends / Dennis L. Olson.
 p. cm.
 ISBN 1-55971-709-2 (hardcover)
 1. Indians of North America--Folklore. 2. Animals--North America--Folklore. 3. Human-animal relationships--North America--Folklore. 4. Legends--North America. I. Title.
 E98.F6047 1999
 398.2'08997--dc21 99-21047

Printed in Singapore